PRIMETIME
Contemporary Art

Art by the GALA Committee
As Seen on **Melrose Place**

All Proceeds to Benefit Fulfillment Fund and Jeannette Rankin Foundation

Auction: Thursday, November 12, 1998 at 7:30 pm

Absentee Bids
This catalogue may be referred to as "MP ART"
Fax for bids only: (310) 274-1205
Bids can be faxed only during the preview days Nov. 9 through 11.
All bids must be received by 4:00 pm on Nov. 11.
Telephone bids must be arranged in advanced.

Exhibition	Catalogue
Monday, November 9 11 am to 4 pm	$20 at the gallery
Tuesday, November 10 11 am to 4 pm	To order on the web: http://www.MPArt.com
Wednesday, November 11 11 am to 4 pm	Front Cover Illustration: Partial Lots: 7, 35
Thursday, November 12 11 am to 4 pm	Back Cover Illustration: Partial Lot: 48 a

SOTHEBY'S
9665 Wilshire Boulevard Beverly Hills, CA 90212
Telephone: (310) 274-0340

IN THE NAME OF THE PLACE

The GALA Network

The communication network of the GALA Committee consisted of thousands of facsimile transmissions of "Product Updates" and notes on the scripts. Ideas were developed through this extensive thermal-paper network. When deemed acceptable by the team, the products were fabricated and shipped to the set for insertion.

ABSENTEE BID FORM

To allow time for processing, bids must be received by 5:00 pm (PST) Wednesday, November 11, 1998. The GALA Committee will confirm all bids by fax by return fax. If you have not received our confirmation by noon on November 12, please resubmit your bid.
Fax: (310) 274-1205

PLEASE PRINT

BILLING NAME

ADDRESS

CITY

STATE ZIP

TEL: DAYTIME

 EVENING

 FAX

SIGNATURE

I request that the GALA Committee enters bids on the following lots up to the maximum price I have indicated for each lot. Bids for items in the silent auction and the live auction can be made.

I understand the absentee bids are executed as a convenience and neither the GALA Committee nor Sotheby's is responsible for inadvertently failing to execute bids or for errors relating to execution of bids. On my behalf, the GALA Committee will try to purchase these lots for the lowest possible price, taking into account other bids.

If identical absentee bids remain, precedence will be given to the first one received.

SALE TITLE

PRIME TIME CONTEMPORARY ART
ART BY THE GALA COMMITTEE
AS SEEN ON **MELROSE PLACE**

DATE

NOVEMBER 9 THROUGH 12, 1998
 SILENT AUCTION
NOVEMBER 12, 1998
 7:30 PM LIVE AUCTION

SALE ADDRESS

SOTHEBY'S
9665 WILSHIRE BOULEVARD
BEVERLY HILLS

PLEASE PRINT CLEARLY IN BLOCK LETTERS

Lot numbers IN NUMERICAL ORDER	Price bid $

CONDITIONS OF SALE

1. *We reserve the right to withdraw any property before sale.*

2. *Prospective bidders should inspect the property before bidding to determine its condition.*

3. *Unless otherwise announced by the auctioneer, all bids are per lot as numbered in the catalogue.*

4. *We reserve the right to reject any bid. The highest bidder acknowledged by the auctioneer will be the purchaser. In the event of a dispute between the bidders, or in the event of doubt on our part as to the validity of any bid, the auctioneer will have the final discretion either to determine the successful bidder or to reoffer and resell the article in dispute.*

5. *If the auctioneer decides that any opening bid is below the value of the article offered, he may reject the same and withdraw the article from sale, and if, having acknowledged an opening bid, he decides that any advance thereafter is insufficient, he may reject the advance.*

6. *All property must be removed by the purchaser at his or her expense on the evening of the sale. The purchaser will be responsible for making any shipping arrangements the evening of the sale. There will be a professional art handling and shipping representative from Professional Packers & Forwarders at the auction to make arrangements for shipping and delivering large articles.*

7. *We are not responsible for the acts or omissions of carriers or packers of purchased lots, whether or not recommended by us.*

8. *Payment by cash, check and most major credit cards.*

GUARANTEE

All works are made by the GALA Committee specifically to be used by and seen on the television production, Melrose Place.

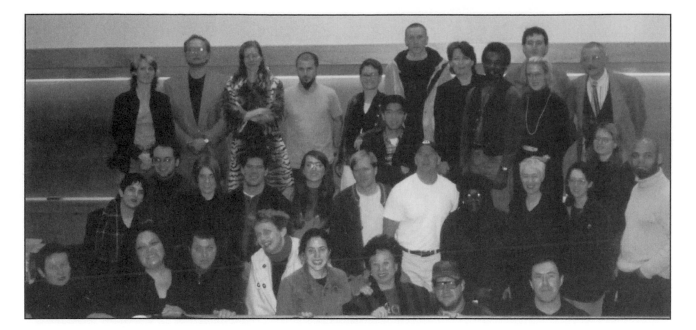

GALA COMMITTEE
1995 - 1998
Gathering of participants in Kansas City, Missouri 01 17 98

In The Name of the Place is a complex collaborative project by the **GALA Committee**, initiated by artist Mel Chin for the Los Angeles Museum of Contemporary Art (MOCA). Working with the *Uncommon Sense* theme of public interaction, The GALA Committee selected a prime time TV program, *Melrose Place*, as the site for creating a massive "condition of collaboration" among an array of individuals, institutions and interests, organized initially around the activity of developing and placing site-specific art objects on the program's sets. During the two-season interaction, the art-enhanced weekly broadcast reached millions internationally. Radically expansive in form, with diverse aesthetics and a wide range of audience/ artist/ television production involvement, *In the Name of the Place* is an experiment that illuminates unexplored, creative territory at the intersection of museums, mass media, and artistic action.

Brent Zerger

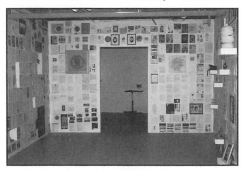

GALA PROCESS ROOM

A floor-to-ceiling, wall-to-wall documentation of concepts and exchanges between the diverse locations and individuals that made up the GALA Committee.

The culmination of the project is the public auction of the collectively-made art works. All proceeds from the auction will go to two non-profit educational organizations, the Fulfillment Fund and the Jeannette Rankin Foundation, to be used specifically to benefit women's education.

FULFILLMENT FUND

The Fulfillment Fund's mission is to identify promising disadvantaged students, some of whom have physical disabilities, assist them to complete high school, broaden their horizons, and encourage them to pursue an advanced education so that they can achieve their maximum potential and become contributing members of our community. The Fund is a "full-service" agency which annually works with 2,000 low-income middle and senior high school and college students, and combines long-term individual and group mentoring and educational outreach with personalized academic and college counseling, drug awareness, arts impact and volunteer programs, paid internships, and guaranteed counseling or vocational school scholarships. It is the comprehensive nature of the Fund's programs that has resulted in a high school graduation rate for Fund students which is nearly twice the rate of students graduating from the Los Angeles Unified School District as a whole. Ninety percent of Fund students attend colleges and universities across the country.

Proceeds from the auction will be used to establish a special fund for young women.

Fulfillment Fund
2801 Avenue of Stars
Suite 250
Los Angeles, CA 90067
(310) 788-9700 phone

JEANNETTE RANKIN FOUNDATION

JEANNETTE RANKIN

Jeannette Rankin was the first woman elected to Congress (November 7, 1916) and a champion for suffrage, peace and participatory democracy. When she died in 1973, she left a bequest to be used to assist "mature unemployed women workers." This bequest of $16,000 became the modest beginning of the Jeannette Rankin Foundation's Women's Education Fund. Awards are given to women 35 years of age or older to pursue a course of technical training or undergraduate degree.

There were only 19 applicants in 1978 for the first award. Now there are hundreds of applicants for the limited number of $1000 awards granted annually. The number of awards made depends in large part upon membership dues and yearly donations.

Applications reveal stories of courageous women seeking opportunities to become the best they can be, often against formidable odds. These women have in common a belief that education and training can provide the key to financial independence and self-fulfillment.

Jeannette Rankin Foundation
P O Box 6653
Athens GA 30604

(706) 208-1211 phone

Live Auction

Lots 1–49

Thursday
November 12
1998
7:30 pm

1

Habit Form
acrylic paint on shaped canvas
37.5 x 24.25 x 1.75 in.

A graph of the number of weekly tv viewing hours
spent by people between the ages of one and twenty.

$700 / 900

2

Chroma Key Blue
acrylic on canvas
approx. 24 x 24 in.

The standard color used for inserting
special effects in film making.

$600 / 800

3

Target Audience
paper, steel, plastic, pigment
18" diameter

The target audience for the MP production is
women from eighteen to forty-nine years old.

$300 / 500

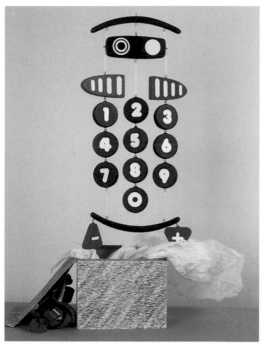

4

Baby Mobile with Wrapping Paper
wood, plastic, metal eye screws, nylon
cord, paper
22 x 13 x .5 in.

Based on a television remote control. The
special gift wrap is rendered in television static.

$500 / 700

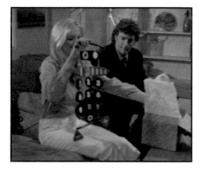

Billy says to pregnant Alison,
"Something for the baby, to keep
you from going totally insane."

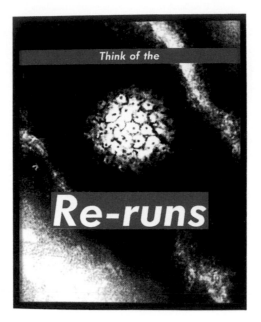

5

Think of the Re-runs
computer generated image
23.5 x 19.5 in. (framed)

Like a virus, television can have an extended life.

$300 / 500

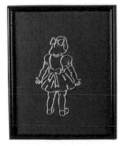 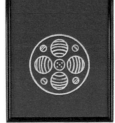

6
RGB
acrylic paint on canvas board (three pieces)
14 x 11 in. each (framed)

A young girl and boy gaze at the mandala, a reel of film, all in the primary colors of light.

$600 / 800

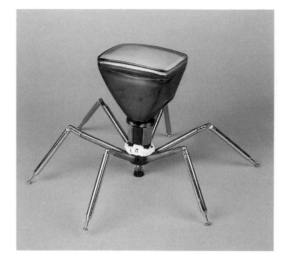

The tv-phage infects the museum scene.

7

tv-phage
cathode ray tube, deflection yoke,
tv antennas
closed: 12 x 14 x 14 in.
extended: 21 x 32 x 32 in.

Television tube version of a T-4 virus

$600 / 800

Electron scanning microscopic image of a T-4 bacteriophage. The discovery of this virus lead to many advances in the field of microbiology.

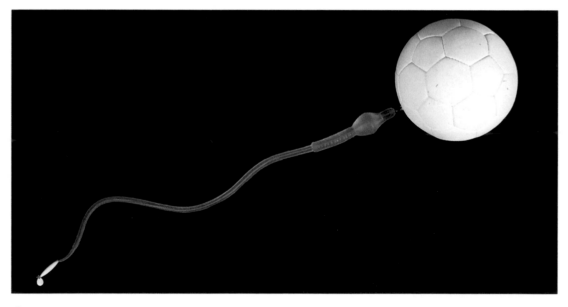

8

Pool Toy
cast synthetic polymer attached by monofilament, enamel on soccer ball
28 x 9 x 9 in.

A biological reference for the pool at *Melrose Place* - a Spermie Wormie to play with in the primordial waters.

$500 / 800

9

Yes or Snow
embossed etchings on rag paper mounted
on enameled masonite in rustic wooden
frame
16.5 x 36.5 in. (framed)

A cool and objective pregnancy test. For a ski lodge
love scene in which Alison becomes pregnant.

$500 / 700

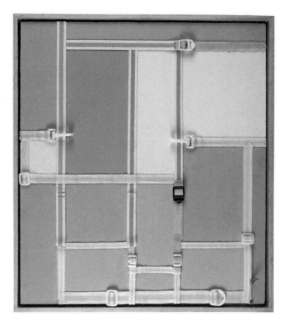

10

Restraining Order
acrylic and nylon straps on wood panel
24 x 18 in. (framed)

A "Mondrian" made of child leashes. Made for a
young collector with parental control problems.

$700 / 900

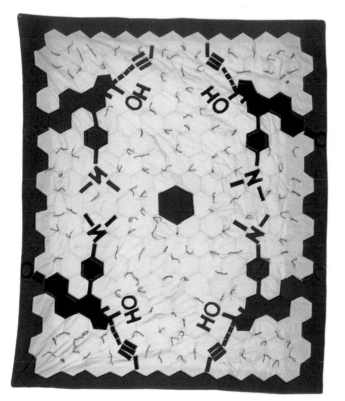

11
RU 486 Quilt
applique on cotton fabric
62 x 53 in.

Handmade quilt with pattern of the chemical structure of the RU 486
drug - an abortion drug used in Europe but until recently banned in
the U.S.

$1000 / 1500

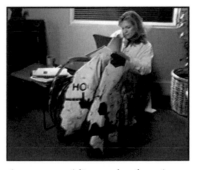

A pregnant Alison, who doesn't
have a choice, works at home under
the **RU 486 Quilt.**

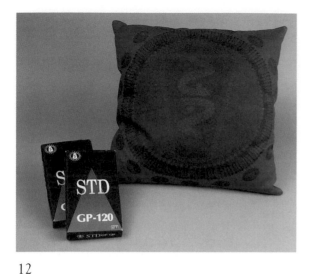

Sidney's blind-date flees the apartment with a pillow made to conceal his irresponsible impulse.

12

HIV Pillow with STD Video Sleeves
hand printed cotton, pillow
15 x 15 x 4 in.

Sexually transmitted diseases and other viruses are recurring GALA themes. Two public service announcements in the form of props.

$200 / 300

13

Safety Sheets
hand silk-screened ink on queen size cotton sheets
one top sheet, one bottom sheet, one duvet cover

She dreams of safe sex. The sheet design is made from unrolled condoms, an image formerly banned by the FCC.

$800 / 1000

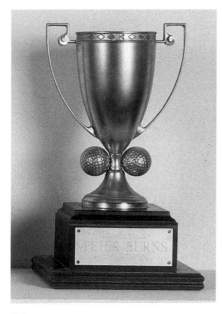

14
Peter Burns' Loving Cup
walnut, golf balls, paint, cast
zinc, brass
16 x 8 x 8 in.

For a man who identifies with his game.

$400 / 600

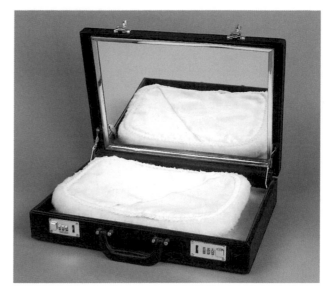

15
Brief Appearances - Powder Puff Briefcase
altered briefcase with mirror, aluminum,
Styrofoam, joint compound, thread, pigment
13 x 17 x 3 in.

You see it every day but never what's inside. Made for
men to make-up an impression.

$700 / 900

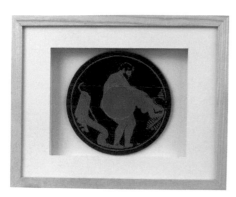

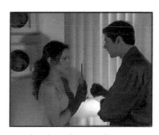

Michael and Jennifer in
front of the **Blue Dots.**

16
Behind the Blue Dots
altered computer images
(two panels)
13 x 16 in.(framed)

Ancient images updated for twentieth cen-
tury public viewing. In Michael Mancini's
beach house.

$400 / 600

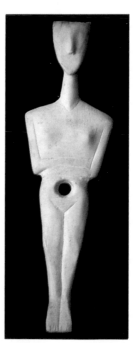

17
Cycladic Idol
hydrostone
16 x 5 x 1 in.

Based on ancient fertility figures made in the
Cycladic Islands. Seen in the beach house.
Originally made for Jo who lost her baby.

$400 / 600

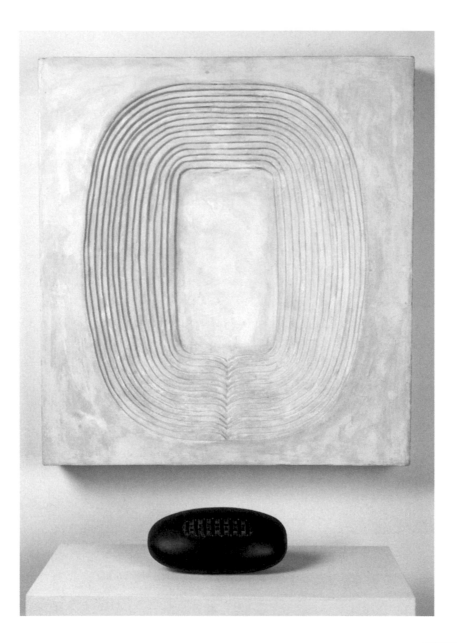

18

Yoni Stadium
Masonite, pine, joint compound, acrylic varnish
32 1/2 x 29 1/2 x 4 in.

The modern male gazes upon a football stadium, similar in shape to the ancient Hindu emblem of female sexual energy.

Laced Lingam
carved granite
8 x 4 x 3 in.

Football laces carved into stone. Sporty expression of ageless form.

sold as one lot $1,500 / 2000

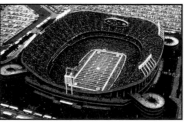

A Football Stadium

The TV blimp shot reveals fallopian-tube-like ramps that lead the faithful into the womb.

Lingam

A Svayambhu, "self originated" lingam from western India.

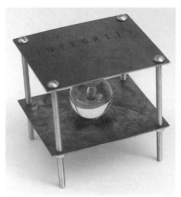

Sydney ponders the empty integrity of a double-dealing lawyer while waiting in his office.

19

Integrity
hand blown glass, engraved
brass plate, steel
4.5 x 5 x 5 in.

A perfume with human attributes based on Duchamp's *With Hidden Noise*.

$500 / 700

20

Ready Made Shovel
rubber
approx. 48 x 8 x 2 in.

Prop from the set of MP seen as found object.

$400 / 600

Hard to Hart. Jane swings solidly from the shoulder and hits Richard squarely in the gut.

Jealous Jane, a bad sport, pitches the brick through Alison's bedroom window.

21

Ready Made Brick
rubber
3 x 5 x 8 in.

Innate object capable of expressing the ire of a spurned lover.

$250 / 350

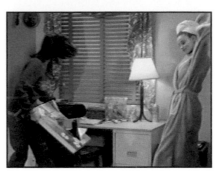

Detail of **The Hoods**

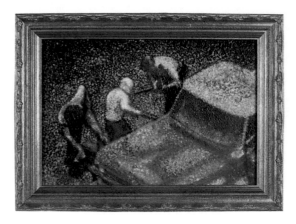

22

Sunday Afternoon on the Ground
digital printout on canvas with acrylic paint
16 x 20 in. (framed)

A San Diego Seurat. For Amanda's apartment.

$500 / 700

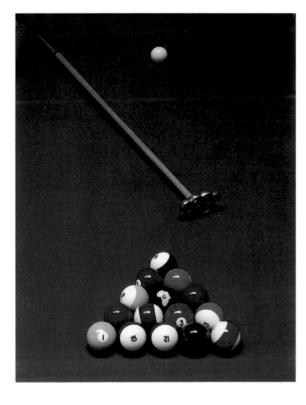

Sydney and Sam fight over the neighborhoods. One in Langley, VA (CIA Headquarters) and the other South Central, LA (Watts Towers).

"Crack" goes the canvas.

23

The Hoods
acrylic on canvas
16 x 20 in. each (four panels)

Four identical paintings were made to be used in destructive retakes of the above scene. All four sold as one lot.

$700 / 900

24 a

Sissy Stick
altered cue stick with cast brass knuckles
60 x 5 in.

Made for a bar fight to abridge the stereotype of gay men as "sissies."

$400 / 600

24 b

Africa is the Eight Ball
regulation size pool balls, one with enamel paint on the 8 ball, plastic rack

Noting racism institutionalized within traditional games and language.

$400 / 600

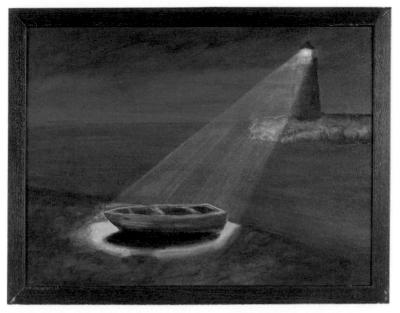

25 a
Lighthouse with Beached Boat

Sam's Early Paintings - Maryland Series (a-d)
acrylic on canvas
13.25 x 17 in. (framed)

The Freudian representations of a young woman's troubled upbringing on the Eastern Shores.

$500 / 700 each

Billy hangs a symbolic portrait of his future wife.

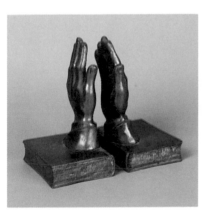

26
Praying, Boasting, Lying Hands
cast iron and bronze
6 x 7 x 5 in. each (two pieces)

A variable sculpture capable of expressing belief, deceit, quantitative information.

$400 / 600

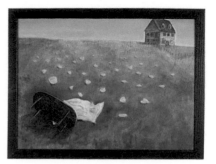

25 b **Sam's World**

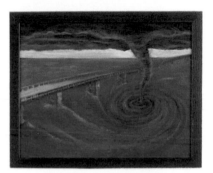

25 c **Revenge of the Bay**

26 d **The Broken Bridge**

25 e **The Cove**

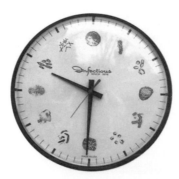

Viral Clock
altered wall clock
14 in. diameter

Commercial clock altered with individual artist's drawings of images of twelve viruses. Included are Yellow Fever, Polio and Tuberculosis, and those most likely to make a strong comeback in the next twenty years according to Johns Hopkins Medical University and the Center for Disease Control (CDC).

$500 / 700

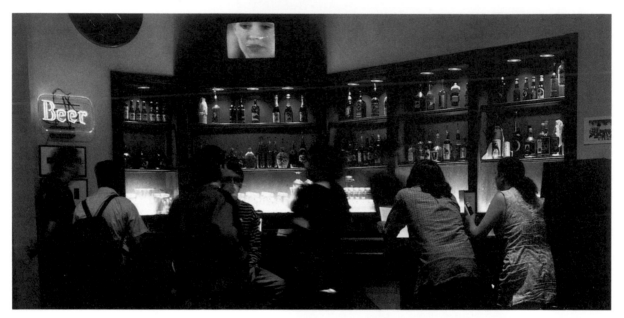

28

Shooter's Bar with GALA Insertions
wood, blown glass, metal, carved granite, commercial glass, paint, electric components, glassware
approx. 12 x 16 x 8 ft

Installation to be sold as one lot.

$5,000 / 10,000

Totaled ceramic commemorative

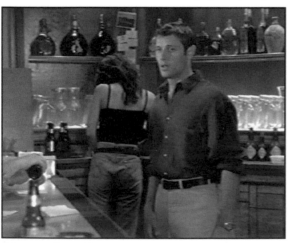

Jake gives last call.

Installation Details
One of the most popular sets on *Melrose Place* was transformed by GALA into a history of the production and consumption of alcohol in America from 1700 to 2000. Each label was designed by individuals of the GALA Committee, allowing proof that collective activity does not negate individual expression. Replica of television set made for museum presentation with complete collection of original labels, bottles and sculptures used throughout season five on *Melrose Place*.

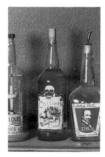

Part of an historic collection for the 1900s.

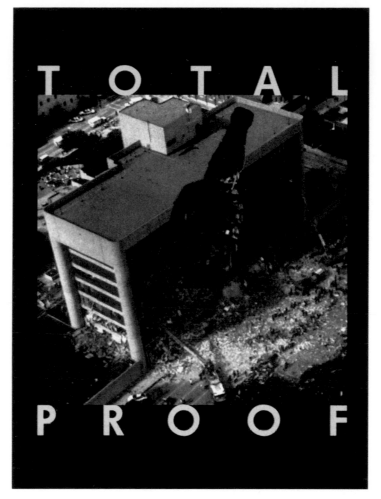

29
Total Proof
computer altered image on foam core
25 x 29 in.

A poster for Alison's office about advertising, the destructive potential
of alcoholism and home grown terrorism.

$600 / 800

30
Olympic Bomb Box
Foamcore box with excelsior and fake
pipe bomb, timer
6.5 x 18.5 x 12.5 in.

Explosive contemporary issues can be defused by
creativity.

$400 / 600

Amanda and Alison at D &D Advertising.

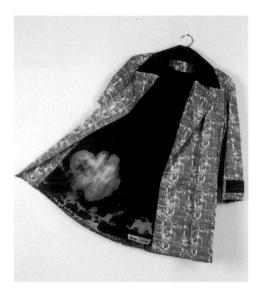

31
Cause and Effect Rain Coat
silk-screen print on hand-made cotton
coat
38 in. length

Made for Kimberly who blew up *Melrose Place*.
Lined with the tragedies of Waco on the inside
and the debris of Oklahoma City on the outside.

$500 / 700

32 a
Bullet Pens
38 cal. casings, brass tubing, pen parts inserted
into a 38 Special cylinder
6 x 3.5 in.

Bullet pens made for the writers of *Melrose Place* to use
for getting the lead out. Gun Purse for Jane's gun-toting
days.

$500 / 700

30 b
Gun Purse
metallic ink on silk
approx. 5 x 8 in.

$250 / 300

Jane, searching for her mother, asks
the mailman if he's been on the
route long. He answers, "Eighteen
years, is that long enough?" as an
AK-47 clip dangles from his bag.

33
Government Issue
altered U.S. Mail Bag with AK-47 Clip
25 x 18 x 6.5 in

This postal bag carries more than one type of magazine.

$700 / 900

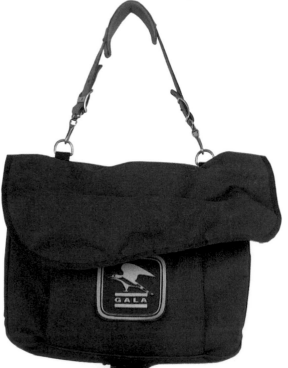

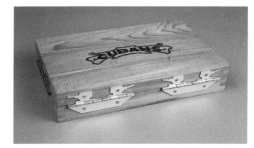

34
Cubans
branded wood, brass,
tobacco
2 x 10 x 8 in.

The brass gun-boat hinges
completely surround the box,
in reference to the continuing
U.S. embargo.

$500 / 700

Billy gives Jake, the father to be, a
box of inaccessible Cuban cigars.

A dying Kimberly is carrying Food for
Thought when she runs into Matt.

With *Melrose Place* in syndication in over
60 countries, GALA will speak to an
international audience.

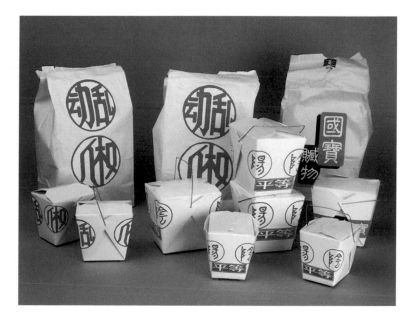

35
Chinese Take Out Human Rights/ Turmoil (Dong Luan)
Yin Yang/ Equal Rights
National Treasures/ Stolen Artifacts

ink stencils on paper boxes and paper bags
various sizes

Three sets of boxes and cartons, each with one of the above double
characters.

$1,000 / 1,500

36
Pacifier Candlesticks
bronze, beeswax
9.5 x 4.75 x 3.5 in. each

Made for the proposal scene between Jake and pregnant
Alison. These candles can shed light on the issue of marriage
as pacification.

$400 / 600

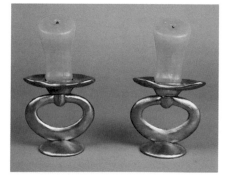

37

Fireflies - The Bombing of Baghdad
acrylic on canvas
72 x 96 in.

At the request of the producers, GALA conceived and made this painting for the "Melrose at MOCA" scene where Kyle discusses art with Amanda.

$2,500 / 3,500

Amanda and Kyle view paintings and sculpture by the GALA Committee at MOCA as they tour the *Uncommon Sense* exhibition. Fiction and reality blur with these two art lovers.

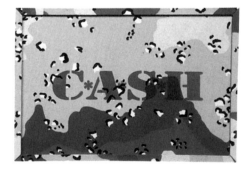

38

C*A*S*H
silk-screen on Desert Storm camouflage fabric, ink, wood
12.25 x 17.5 in. (framed)

The camouflaged motive for war.

$500 / 700

39

Mosquito Brooch
silver, glass, steel
3.75 x 1.75 x 7.5 in.

Jane asks for a pin to use on Richard
Hart's body. Sam offers her the antique
brooch that was her grandmother's. The
Aedes Egypti mosquito is a carrier of
Yellow Fever, one of the diseases the CDC
expects to return with a vengence.

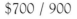

Jane makes sure Richard is
really dead, and spreads the
GALA art infection.

$700 / 900

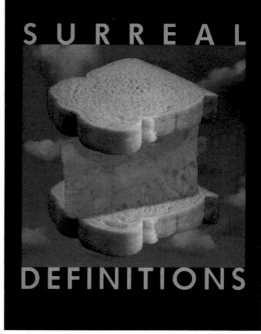

40

Surreal Definitions
computer generated image on Foamcore
49 x 19 in.

In Alison's office at D&D Advertising. Made after
reading a *New Yorker* article on Rwanda in which a
U.S. military intelligence officer was quoted as say-
ing, "Genocide is a cheese sandwich. What does
anyone care about a day old cheese sandwich?"

$600 / 800

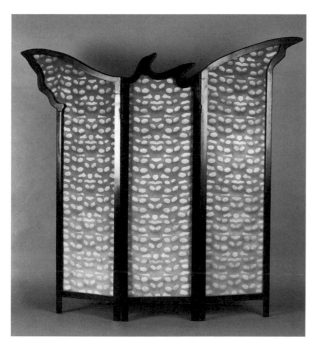

41

Spotted Reason
hand made silk-screen on cotton, wood frame
64 x 60 x 1.5 in.

The Spotted Owl is an endangered species in California.
GALA suggests "the sleep of reason" produces environ-
mental destruction. Made for Jane's boutique.

$800 / 1,200

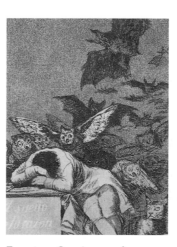

Francisco Goya's most famous
etching in the *Caprichos* inspires
many generations of social
activism in the arts.

Sam weeps.

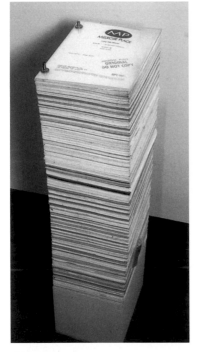

42

43

42

Script Stack (*Melrose Place* scripts bolted together in a stack)
paper, steel
approx. 40 x 8 1/2 x 11 in.

A season's worth of the dizzy and complicated scripts of Melrose Place. Used by the GALA Committee to invent additional layers of meaning and insertion of products, they are finally abstracted into a minimalist masterpiece.

$400 / 600

43

Uncommon Constructivism
acrylic on canvas
36 x 42 in. (framed)

The blueprint of the exhibition *Uncommon Sense*, at MOCA. Executed with color-coded flair. For Craig's art collection.

$800 / 1,000

44

Magnetic Monet
wood, plate steel, magnetized rubber, digital printout on paper
26.5 x 29.25 in. (framed)

Color of buds and flowers represents the men and women of Melrose Place. Floating in the impressionistic waters of a Monet, their magnetism allows for infinite combinations of cross-pollination.

$800 / 1,000

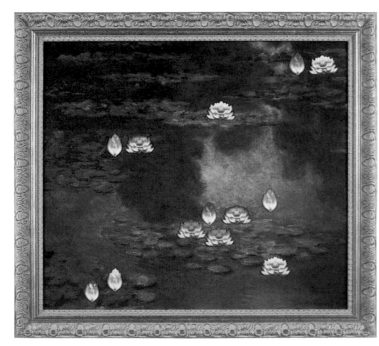

44

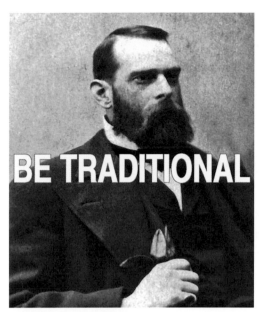

BE TRADITIONAL

Detail of Amanda's Bottled Water Campaign.
Image of Albert Pinkham Ryder.

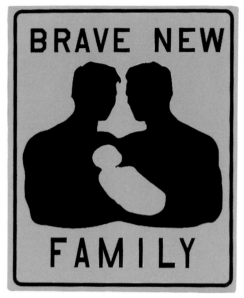

46. Detail of Billy's Family Values Campaign.

Amanda's traditional and
original pitch for art history.

46. Detail

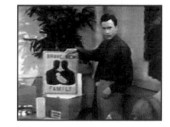

Billy packs up his award-
winning campaign.

Installation view at MOCA

45

A. P. Ryder Bottled Water Campaign
computer-generated images on
Foamcore
24 x 16 in. each (four panels)

Props from Amanda's ad campaign. Albert
Pinkham Ryder was a famous 19th century
American artist known for his moonlit marine
paintings and his imaginative style.

Lot of four panels $800 / 1,000

46

Family Values Campaign
industrial vinyl on aluminum
20 x 30 in. (two panels) illustrated
16 x 20 in. (two panels)

Billy Campbell wins the product placement
award for his Roadside Family Values
Campaign.

Lot of four panels $1,500 / 2,000

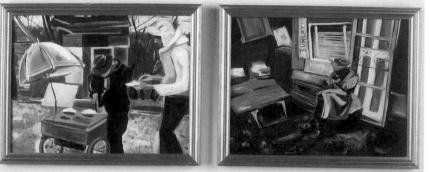

47

**Paintings for John Waters,
Mortville Pies and Sunday Services**
oil on panels
12 x 16 in. each (two panels)
(framed)

Made for a scene with Sam's father, an
ex-con from Baltimore.

$600 / 800

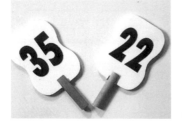

Curvaceous auction paddles made for selling *Marilyn Monroe's House* painting at a *Melrose Place* version of charity auction. The numbers are based on her measurements.

The bidding escalates at a *Melrose Place* benefit auction.

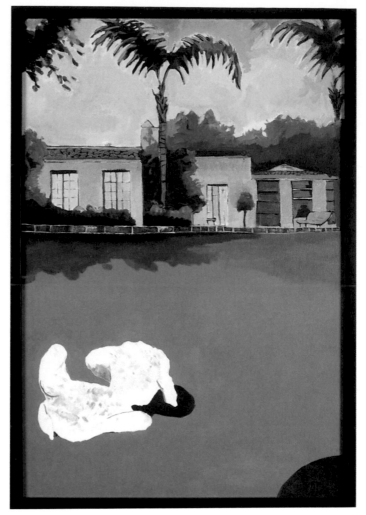

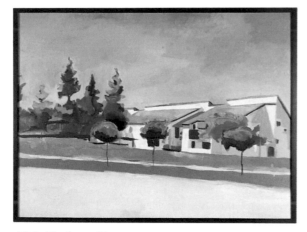

48 b Rodney King

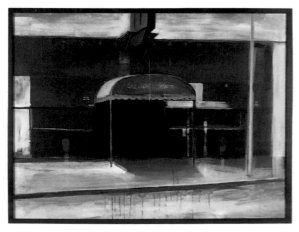

48 c Viper Room

48 a
Sam's Late Paintings - Sunny LA series
Marilyn Monroe's House
acrylic on canvas
36 x 24 in. (framed)

Painted from a police archive photograph taken of her bungalow the day of Marilyn Monroe's death. Sold with auction paddles.

$1,000 / 1,500

All of Sam's paintings in this series brightly depict the dark side of Los Angeles.

48 b
Rodney King
acrylic on canvas
24 x 36 in. (framed)

Site of the Rodney King beating.

$800 / 1,200

48 c
Viper Room
acrylic on canvas
24 x 36 in. (framed)

$800 / 1,200

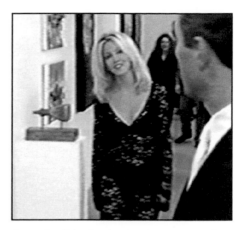

Amanda glides by the iconic presence of **TV Tube** at the *Melrose Place* opening night of *Uncommon Sense*. **The Hoods** hangs in the background.

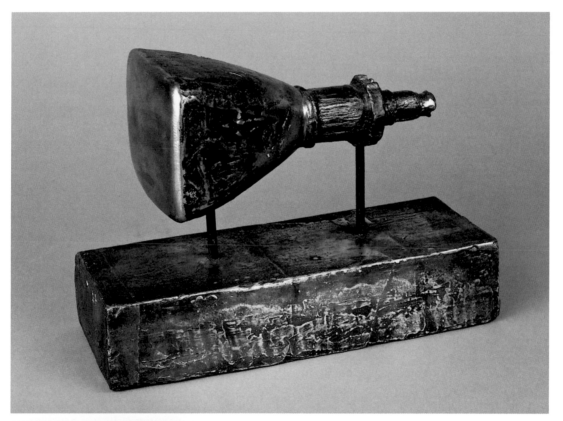

Advertising executive, Billy Campbell, holds a replica of the **TV Tube,** which he receives as the GALA Committee Award for Product Placement.

49
TV Tube (after Johns)
bronze, steel
10 x 11 x 4.75 in.

Johns linked popular culture and art. GALA Committee fuses television and art. In a worthy homage to both, a cathode ray tube is eternally rendered in cast bronze, transfixing, like Johns' *Flashlight,* the worlds of television and art history.

$800 / 1,200

Silent Auction

Lots 50–101

Monday – Thursday
November 9 – 12
1998
11 am to 4 pm

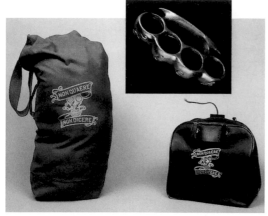

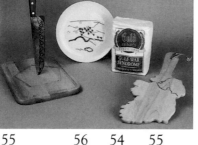

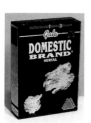

51 50 52

53

55 56 54 55

54

57

58 59

61

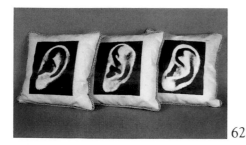

62

50. Lick
cast brass, engraved
4.25 x 2.25 x.75 in.
For a bar scene licking. $300 / 400

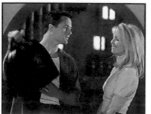

51. Non Quaere, Non Dicere
(Don't Ask, Don't Tell)
silk screen ink on U.S.
Army regulation size duffel bag.

$300 / 500

52. Bowling Bomb & Bag
bowling ball, wood, cotton
cord, pigment on vinyl bag
24 x 14 x 14 in.
Kyle's Smart Ball knows Latin.

53. Cherry Key Ring $400 / 600
hammered brass
5 x 1 x 1 in.
Made for a new recruit
to *Melrose Place*. $200 / 300

54. a. Domestic Brand Cereal Box
b. Gulf War Flour
paper, ink, wheat flour, computer generated images
a. Breakfast for Matt and Dr. Dan.
b. Flour for Kyle's kitchen. $250 / 350

55. a. M1A1 Steak Knife
acid-etched high carbon steel knife
14.75 x 2.175 x .75 in.
b. Ireland & Pentagon Cutting Boards
carved maple boards (two) 11 x 17 in. each (approx.)
One country cuts back and another stays divided.
$400 / 600

56. Double Fault Line Plates
hand glazed and fired clay plates
10 1/2 in. diameter (each)
Geologic and social fault lines
of Los Angeles.
Five sets (eight plates per set)

$400 / 600

60

57. Archisexual Prints with Magnetic Fig Leaves
computer generated image on steel with magnetic fig leaves.
14 x 11 in. each (framed) two panels
Mechano-morphic sex, with magnetic censors. $400 / 600

58. Flow Chart - Moon Calendar
computer designed images on paper, desk blotter
15 x 25 in.
Used by the receptionist at Mancini and Burns.
$200 / 300

59. Birth Control Pillbox (with fertility goddess on cover)
Plastic sculpting medium
3 x 3.5 x .75 in. $200 / 400

60. Libidinal Economy by F. Lyotard
approx. 11 x 8 x 1 in.
A must-read for the clerk in a motel with an hourly rate.
$200 / 300

61. Purse With A Secret
designer purse, paper, ink
10 x 8 x 3.5 in.
$300 / 500

62. Ear Pillows
silk-screen ink on cotton,
18 in. square (3 in lot)
$400 / 600

Megan's ears don't look like these.

63. It's a Set Up
computer generated image on Foamcore
24 x 19 in. (framed)
For the bar. $300 / 500

63

64. One Hand Praying
plaster, velvet, wood, paint
approx. 16 x 13 in. (framed)
Dürer meets Zen.
 $400 / 600

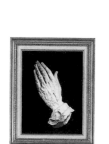
64

65. Billy Sketch
pencil sketch on drawing pads
14 x 11 x I in.
From Billy's modeling scene with Sam.
 $250 / 350

66. Nettle Print
mounted computer generated
image
24 x 18 in.(framed)
An image from the cult of
Milarepa for Sam's studio.
 $250 / 350

66

65

67. Burning Churches Window
metal tape, paint, glass, wood
33.5 x 19.5 in.
Reference to churches burned in the American South.
 $600 / 800

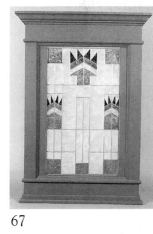
67

68. Little Southern Devil (LSD) after David Smith
hand-hammered copper, brass and steel
approx. 60 x 12 x 7 in.
Coat rack with art historic attitude.
 $600 / 800

69. Background Information
computer altered images on
board (four panels)
12 x 9 in. ea. (framed)
Beatles imagery from Abbey
Road hidden in Shooter's
Bar.
 $300 / 500

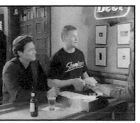

68

69

70. S-G (after Johns)
charcoal on paper
21.5 x 17.5 in. (framed)
S-P-E-L-L-I-N-G it right.
 $400 / 600

70

71

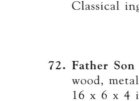

72

73

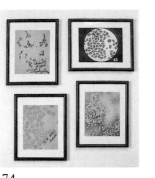

74

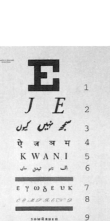

75

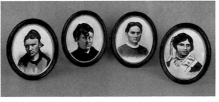

76

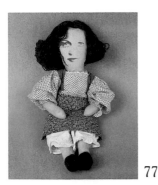

77

71. Grecian Formula
computer enhanced photograph
16.25 x 18.25 in. framed
Classical ingredients for soap.

$300 / 500

72. Father Son Trophy
wood, metal
16 x 6 x 4 in.
Oedipal Prize.

$300 / 500

73. Barbie Mask
carved wood, pigment
8 x 6 x 2 in.
Mask with Barbie Doll
features.

$400 / 600

74. Celebrity Virus Close Ups
permanent ink on photographs.
14 x 1 x 1 in. (each) (framed)
Autographs by microbial personalities.

$600 / 800

75. Eye Chart
mounted computer generated image
21 x 14 in.
"I don't understand. Why?" Repeated phrase in various
languages ranked by literacy studies conducted by the
U.N.

$400 / 600

76. Prostitute Ancestors
computerized portraits from 19th century
each: 12 x 10 x 1 in. (framed)
Made for Megan's stay in the Beach House.
Lot of four $200 / 400

77. Sydney Doll
silk-screen ink on cotton
Jane's sister (unknown to Jane) waits for her at her
childhood home.
14 x 7 x 2.5 in.

$400 / 600

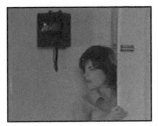

78. Heroin Clock
commercial clock with
altered hands
12 in. diameter
Time needs a fix.
$350 / 450

79. Quantum Cat Clock
plastic clock, wood, steel
approx. 13 x 7 x 5 in.
A reference to "Schrodinger's
Cat" - a quantum physics
puzzle.
$300 / 500

80. Barbie Bug Sheets
ink on cotton sheets
queen-size
$200 / 400

81. Poodle Skirt
appliqued felt
size 4
For a character with multiple personalities
bound for Hades.
$400 / 600

82. Against PETSA
(People for the Ethical Treatment of Stuffed Animals)
acrylic fabric and stuffed animal parts on wood board
24 x 18 in. each (eight panels)
Made for an analyst's office; he likes a less-filling
abstraction.
$1000 / 1500

83. Sam's Late Paintings
a. Chateau Marmont
b. Nicole Brown Simpson's House (not pictured)
c. Ambassador Hotel (not pictured)
acrylic on canvas 36 x 24 in. (framed)
each $600 / 800

85a Melrose Pool Water
water in glass vial
4 x 3/4 in. each
85b Melrose Air
rubber, glass, air
5 x 3/4 in.
Captured on the set.
$300 / 500

84. Sam's Late Paintings (continued)
a. Melrose Courtyard
b. O.J.s Brentwood House
c. Sharon Tate House
d. La Bianca House (not pictured)
acrylic on canvas 36 x 48 in. (framed)
each $800 / 1200

86. For LeAse
Hawthorne Courts
commercial printed sign
48 x 24 x 16 in.
A scarlet "A" for undesir-
ables in the neighborhood.

$250 / 350

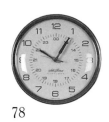

78

79

80 detail

81

82

83a

84a

84

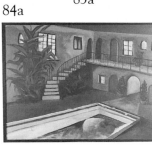

84b

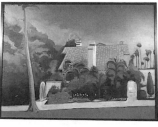

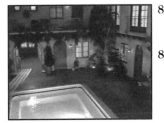

86

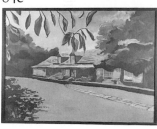

84c

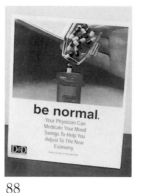

87

87. Diet Pill Necklace
Dexatrim pills on
string with varnish
1 x 5 in.
Ready to wear appetite
suppressants. Made for
the teen with angst.
$200 / 300

88

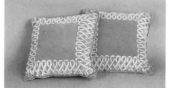

89

88. Be Normal
computer printout on standup placard
10 x 7 in.
For speed-addicted Doug, the price was not the issue.
$250 / 300

89. Breast Cancer Ribbon Pillows
silk-screen ink on cotton, pillows
18 in. square

$300 / 400

90. Gag Order
hand-screened ink on silk
24 in. square
Black and white fingers
accuse each other.
(Used to gag Jane during
a robbery).
$350 / 450

90

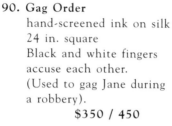

**91. Aedes Egypti
Heavy-Metal T-shirt**
transfer iron-on cotton
t-shirt
His band is infectious.

$350 / 450

91

92

94

93

92. Paint brush Coffin & LA Colors Palette
wood, paint brushes, paint
various sizes
They say painting is dead. Long live the diverse
demographics of LA.
$300 / 400

93 Witches Broom
shaped, burn and branded broom
Effigy to sweep away the persecution of women.

$300 / 400

94. Seamstress Distress
bolt of hand printed cotton
Triangle Shirt Factory
New Store Hours
Your Clothes Are Made By Somebody
computer generated images on Foamcore
8 x 10 in., 10 x 9 in. and 6 x 8 in.
All made for Jane's boutique as a labor of love.
$250 / 350

95. House Lamp
Georgia pine, cloth shade
with paint application
electric components
30 x 14 x 14 in.
Continuous profile of
Speaker of the House in the
manner of Bertelli.
$400 / 600

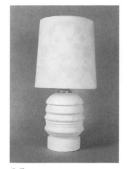

95

96. We Three Kings
silk-screen on paper
approx. 12 x 30 in.
King Carlos the IV, Elvis, Aaron Spelling
$400 / 600

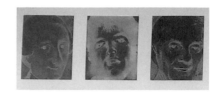

96

97. Wilhelm Reich Diploma
lithograph, wood, steel wool, wool fabric, steel
20 x 24 x 2 in. (framed)
This document has orgonic capabilities
$300 / 500

98. Dr. Charles Drew
charcoal on paper
24 x 20 in. (framed)
Famous doctor in infamous
doctor's office.
$300 / 500

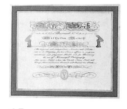

97

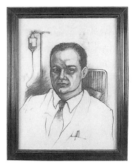

98

99. a. Billy's Tie (with Brooke's scar)
handmade silk tie with hand printed pattern
(white tie w/ red)
53 x 3 in.
Brooke's blood on Billy's Tie. She died in the pool.
$250-350

99. b. Germ Tie
handmade silk tie with hand printed pattern
(pale green tie w/ brown)
53 x 3 in.
Design of microbes in reoccuring patterns. Made for
the doctors of Wilshire Memorial.
$250 / 350

99

100. a. Freud/Ruth Photograph
 b. Kervorkian/Burns Photograph
computer altered images on paper
11 x 8.5 in.
10 x 8 in.
A morph of two famous doctors who wrote about sex.
A morph of Dr. Kervorkian and Dr. Peter Burns, mercy
killers. Lot of two $200 /-300

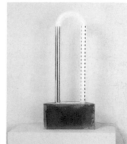

100

101.Logo Light
steel, fluorescent tubing,
metal tape, electrical
components
28 x 11.75 x 5 in.
The Spelling logo seen as
light sculpture.
$400 /600

101

PROVENANCE : Exhibitions / Episodes Histories

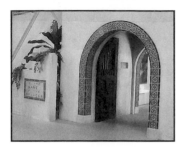

The Entrance to *In the Name of the Place* at MOCA'S *Uncommon Sense* Exhibition.

EXHIBITION RECORD

In the Name of the Place 1997 - 1998

Museum of Contemporary Art Los Angeles, CA

Kwangju International Biennale Kwangju, Korea

Grand Arts, Kansas City, MO

Lawing Gallery, Houston, TX (selected presentation)

LEGEND

C	Cover
BC	Back Cover
IBC	Inside Back Cover
EP	End Page
NP	Not Pictured

Note: Following is a partial list of products that have "made camera." Does not include repeat appearances in subsequent episodes.

NAME OF GALA PRODUCT	ORIGINAL APPEARANCE	PRODUCTION No.	LOT No.
Safety Sheets	Devil In A Wet Dress	2395114	13
Surreal Definitions	Ruthless People	2395117	40
It's a Set Up	The Burning Sofa	2395118	63
Total Proof	The Triumph of the Bill	2395119	29
Rubber Shovel	Living with Disaster	2396126	20
Spotted Reason	Over Dick's Dead Body	2396127	41
House Lamp			95
Be Normal			88
Sketch Book			64
Fragile! Labels on Boxes			NP
Mosquito Brooch	Moving Violations	2396128	39
Shooter's Bar/Bar Graph			28
Double Fault Dinner Plates	HunkaHunka Burning Love	2396129	56
Marilyn Monroe Painting	Un-Janed Melody	2396130	48a
AP Ryder Water Campaign	Jane's Addiction	2396131	45
Ready Made Brick			21
Change the Guard of Despair	Young Doctors in Heat	2396132	NP
Against PETSA			82
Sunny LA/Death and Destruction Paintings			48, 83, 84
Burning Churches Window in Kyle's			67
HIV Pillow			12
Spotted Reason			41
Chinese Take-Out	Farewell Mike's Concubine	2395134	35
Domestic Brand Serial	Nice Work If You Can Get It	23951355	4
Sidney Doll			77
Unveiling of the Ambassador Hotel			84
Government Issue	Sole Sister	2396136	32
Little Southern Devil (LSD)			68
Show Hosts GALA	Quest for Mother	2396137	EP
Background Information			69
Sketch Book with Billy			65
Milarepa Objects			92

NAME OF GALA PRODUCT	ORIGINAL APPEARANCE	PRODUCTION No.	LOT No.
Chroma Key Blue			2
Praying Hands			26
Melrose Courtyard	Crazy Love	2396138	84
Yes or Snow			9
Auction Scenes:			
Marilyn Monroe House / Auction Paddles			48
Sam's World	The Accidental Doctor	2396139	25
Revenge of the Bay			25
Lighthouse with Boat			25
Pool Toy (spotted in Billy's closet)			8
Aedes Egypti Heavy Metal T-Shirt	Escape From L.A.	2396140	91
Pacifier Candlesticks	The Eyes of the Storm	2396141	36
Nicole Brown Simpson's Walkway			83
Cheese Chart in D&D Advertising			NP
Double Fault Dinner Plates in Kyle's	Better Homes and Condos	2396142	56
Cubans	Great Sex-pectations	2396143	33
Baby Mobile with Static Wrapping			4
New Grant Dad at Bachelor Party			NP
The Hoods			23
Target Audience (Spotted in Shooter's)			3
Cherry Key Ring	Catch Her in a Lie	2396144	53
Chateau Marmont painting	Men Are From Melrose	2396145	83a
O.J.s Brentwood House			84
Quantam Cat Clock	Frames Are Us	2396146	79
House Lamp			95
Logo Light	Screams From A Marriage	2396147	101
Habit Form			1
RU 486	101 Damnations	2396148	11
Hawthorne Courts			86
Reich Diploma			97
Portrait of Dr. Charles Drew			98
Libidinal Economy			60
Moon Calendar	From Here To Maternity	2396149	58
Integrity			19
Broken Bridge	Last Exit to Ohio	2396150	25
Bowling Bomb and Bag			52
Melrose at MOCA	De Ja Vu All Over Again 2	396152	C
Fireflies -The Bombing of Baghdad			37
tv-phage			7
TV Tube			49
Viper Room			48
Think of the Re-runs			5
Ear Pillows			62
Behind the Blue Dots			16
Oval Office	All Beths Are Off	2396153	NP
Cycladic Idol			17
Laced Lingam			18
Coyote in Babylon			IBC
Barbie Mask	Ultimatums And The Single Girl	2396154	73
GALA Committee Award	A Christine Runs Through It	2397179	NP
Brave New Family	Divorce Dominican Style	2397184	46

UPDATE

Image from the GALA COMMITTEE Historic Archives

It is 2021, a quarter century after the GALA Committee initiated its viral infection of the global electronic net. As we now know, that world historic event started humbly enough with the GALA Committee's gentle invasion of its first host, *Melrose Place*, a kitschy if surprisingly clever soap opera destined for the recycling bin of syndicated nostalgia, which instead found itself not only remembered but revered for its pioneering effort to creatively fuse the worlds of art and television. Who could have known that this small yet unprecedented collaboration between the television veterans who produced *Melrose Place* for Aaron Spelling (mega-producer Tori Spelling's father) and the GALA Committee artists would lead to a profoundly radical transformation of worldwide art, entertainment, communication and government.

GALA's non-commercial PIMs (product insertion manifestations) began to take hold with the introduction of HDTV (now obsolete.) Popular VVs and F2B / B2F parties (aka Vice Versas and Foreground to Background) were the way to watch PIM-affected programs. Meanwhile, in the academic world, multi-dimensional conceptual perceptual field dynamics grew more powerful as CPOs (Conceptual/Perceptual Oscillations) produced a cascade effect of democratic expression and desires. The worldwide fan net, once under the control of consumer/media marketing professionals, had no choice but to rethink their strategies to match the yearning for ideas provoked by the new forms of intelligent simulevel entertainment.

From the perspective of twenty-five years, it is easy to see the GALA Committee's historical predecessors (it also helps being wetwired into the Global Instant Database.) Throughout the 1980s and 1990s, ACT UP, the slashers, Paper Tiger Television, the Tape Beatles, Emergency Broadcast Network, the Barbie Liberation Organization, local TV pirates, and indigenous media groups made guerilla raids on television. Using the cultural terrorist tactics of poaching, hacking, slashing and jamming, these groups of artists and activists created a new electronic folk culture out of the materials of mass-produced culture. The GALA Committee tweaked those tactics to develop a more viral strategy of infection and mutation that eventually spread through the whole electronic realm.

MELROSE SPACE, as the collaboration between the GALA Committee and the television producers came to be called, soon sparked similar projects as people around the world began to reinvent their relation to television and the public sphere. Some projects worked with the existing shows while others created new public spheres for art within the world of broadcast television. The Hollywood film industry, by contrast, remained impervious to any art influences and eventually withered away. In the U.S., President Clinton's leadership in folding the FCC into the NEA showed yet again that her vision of the role of the arts in American life went far beyond anything that either of her parents had been able to accomplish.

We used to watch television. Now we live in it. Improbably, it was the GALA Committee's fuzzy-grained millisecond presence on *Melrose Place* that inspired the new forms of truly interactive virtual environments that we inhabit today. As Amanda Woodward often said, there's no predicting the future.